NICOTEXT

Stupedia

Copyright © NICOTEXT 2009 All rights reserved.
NICOTEXT part of Cladd media ltd.
www.nicotext.com
info@nicotext.com

Printed in Poland
ISBN: 978-91-85869-46-6

Imagine a world in which every single person
on the planet is given free access to the
sum of all human knowledge.

- Jimmy Wales, Founder of Wikipedia

■ ... Wine can be made from substances other than grapes, including marijuana.

■ ... The inspiration for the 2001 horror film Texas Night Train was the song "Moppin' the Floor with My Baby's Head".

■ ... One of the founders of the International Time Capsule Society estimated that over 80 percent of time capsules will be lost before they are opened.

▨ ... Murphy's Law states that "if you write anything criticizing editing or proofreading, there will be a fault of some kind in what you have written".

▨ ... The partition of a uterine septum can extend caudally and result in a double vagina.

▨ ... Large sandstone boulders rest atop trees in Yellowwood State Forest and no one knows how they got there.

■ ... Christopher Smart's The Parables of Our Lord and Saviour Jesus Christ was mocked for its dedication to a three-year-old child.

■ ... Grand Duchess Anna freed her husband Vytautas the Great of Lithuania from a prison in Kreva by dressing him in women's clothes.

■ ... The German-American confectioner Charles F. Gunther claimed to own the remains of the serpent from the Garden of Eden.

... The Irish Greyhound racing regulator Bord nagCon includes Viagra on its list of banned substances.

... Legend has it that anyone who spends a night at Tinkinswood on the evenings before May Day, St John's Day (23 June), or Midwinter Day, would either die, go mad, or become a poet.

... Murray Jarvik and Jed Rose, who invented the nicotine patch, could not get approval to conduct their research on human subjects and performed the initial tests of the patch on themselves.

■ ... The first airmail of the United States was a personal letter from George Washington carried on an aerial balloon flight from Philadelphia by Jean Pierre Blanchard.

■ ... The Museum of Texas Tech University was housed in a basement for approximately thirteen years.

■ ... Instead of making a triumphant entry to Harar, Ethiopia after the Battle of the Ogaden, Italian general Rodolfo Graziani tripped and injured himself at a local church.

▨ ... The Podgórski sisters—six-year-old Helena and her teenage sister Stefania—harboured thirteen Jews for over two years in the attic of their house during the Holocaust.

▨ ... South Park Lofts in Los Angeles, originally an eight-story parking garage, was converted to lofts, whereupon residents complained about a lack of parking.

▨ ... Famous Benjamin Franklin impersonator Ralph Archbold is married to a woman who impersonates Betsy Ross.

■ ... Eat This Book has been criticized as "basically a book-length infomercial" for the International Federation of Competitive Eating.

■ ... The British radio sitcom Safety Catch is built around the moral dilemmas of a man who inadvertently became an arms dealer.

■ ... Somerset cricket captain Reggie Ingle maintained his hay fever was made worse by train journeys, and travelled in the luggage rack to avoid the dust at lower levels.

■ ... 19th-century archaeologist Isaiah Deck proposed pulping linen from Egyptian mummies into paper, to meet a paper shortage in America.

■ ... In rugby union, New Zealand has only lost four Test matches at Carisbrook stadium in over one hundred years.

■ ... Exhibits at the New York City Police Museum include the machine gun used by Al Capone's gang in the 1928 murder of Frankie Yale.

■ ... F. Scott Fitzgerald wrote his debut novel This Side of Paradise in a successful attempt to convince Zelda Sayre to marry him.

■ ... Western Kentucky University's Van Meter Hall is said to be haunted by the ghost of a worker who died due to seeing an airplane for the first time.

■ ... Bodybuilding champion Victor DelCampo was inspired to pump iron by the Incredible Hulk comic books.

▨ ... The Greencards are a Texas bluegrass band known for their Americana sound, but comprise two Australians and an Englishman.

▨ ... Rock climber Peter Harding developed the art of hanging from one hand jammed into a crack, while smoking a cigarette with the other.

▨ ... During the 1989 Revolution, Romanian actor Victor Rebengiuc appeared on television with a toilet paper roll, as a symbol of "wiping out" the communist regime's traces.

■ ... The Tang Dynasty eunuch Li Fuguo, whose assassin had cut off his head and one of his arms, was buried with a wooden head and a wooden arm.

■ ... A heckling comb is used when hand-processing flax to comb out and clean the fibres.

■ ... The Pike Place Fish Market is a Seattle, Washington fishmonger known for throwing fish to customers.

■ ... A subspecies of Black Lemur is the only primate other than humans to have blue eyes.

■ ... "Eggs" of the foul-smelling and insect attracting Dog Stink-horn (a small thin, phallus-shaped woodland fungus) have been eaten with relish in West Virginia.

■ ... The Norwegian National Rail Administration owns all 4,114 km (2,556 mi) of railways in Norway, but does not operate any trains.

■ ... Salem Hospital has the busiest emergency room in the state of Oregon.

■ ... Through Khitan, the Islamic rite of male circumcision, Muslims are the largest single religious group to circumcise males.

■ ... The blue bottle fly (Calliphora Vicina), the green bottle fly (Lucilia Illustris), the hairy maggot blowfly (Chrysomya Rufifacies), the black blow fly (Phormia Regina) and the coffin fly (Megaselia Scalaris) are useful tools to forensic entomologists in determining the time of death of a corpse.

■ ... Argentine adventurer Emilio Scotto had only US$306 when he left Buenos Aires in 1985 on his record-breaking 10-year motorcycle journey.

■ ... There are 64 varieties of mammal in Tam Dao National Park in Vietnam and some are on the menu.

■ ... In 1993, police officer Bob Geary launched a successful ballot initiative in San Francisco, California to allow him to carry a ventriloquist's dummy on patrol.

▨ ... Lloyd Seay, described by NASCAR founder Bill France, Sr. as the "best pure race driver I ever saw", was killed by his cousin during a dispute in the family's moonshine business.

▨ ... Diverse Harmony is the first gay-straight alliance chorus in the United States.

▨ ... The sexual script is a sociological analysis of what leads up to sexual intercourse.

■ ... Young Heliobolus Lugubris lizards scare off predators by imitating certain acid-squirting ground beetles.

■ ... 80% of all British banknotes are contaminated with drugs.

■ ... Elvis Presley is said to have made an impromptu performance at Colonial Gardens in Louisville's Senning's Park, while visiting his grandparents nearby.

■ ... While the 2003 Norwegian film Buddy was described as "simple" in the Norwegian press, a U.S. reviewer called it "overly plotted".

■ ... The Plumed Whistling Duck eats by cropping vegetation rather than diving in water, as other ducks do.

■ ... Charles Martin Hall, working as an amateur chemist in a shed, developed what became the Hall-Héroult process for extracting aluminium.

▨ ... A spite house is a house built to annoy and aggravate some-one, usually a neighbour.

▨ ... The larvae of primary screw-worm flies feed on living tissue, but secondary screw-worm flies feed only on necrotic tissue.

▨ ... Since 2006 Beijing has a legal limit of one dog per family.

■ ... Bhutan has a low crime rate and is the first nation in the world to ban tobacco sales.

■ ... Edgar Allan Poe wrote "The Raven" while living at what is now called Edgar Allan Poe Cottage in the Fordham section of The Bronx in New York City.

■ ... After Norwegian filmmaker Odd F. Lindberg made a documentary exposing inhumane Norwegian seal hunting methods, the hostile reaction encouraged him to emigrate.

■ ... One of Catherine de' Medici's court festivals featured an artificial whale that spouted red wine when harpooned.

■ ... The Rose Bedeguar Gall was used as a cure for baldness, colic and toothaches.

■ ... British wine critic Stuart Pigott published five commandments regarding wine drinking and appreciation, including "for wine, there is no connection between price and quality".

■ ... After discovering a suitcase with US$800,000 in Maletinazo (the suitcase scandal), policewoman Maria de Lujan Telpuk appeared on the cover of the Argentine and Venezuelan editions of Playboy.

■ ... The Maori name for the New Zealand Agency for International Development is Nga Hoe Tuputupu-mai-tawhiti, which means "the paddles that bring growth from afar".

■ ... The inbred villagers of Stoccareddo in Italy are a medical phenomenon, with unusually low frequencies of hypertension, strokes and heart attacks despite a high-cholesterol diet.

▣ ... Thursday of the Dead is a springtime feast day shared by Muslims and Christians in the Levant that involves colouring eggs, visiting the cemetery and distributing food to the poor.

▣ ... The Eurymedon vase has been cited as evidence of Ancient Greek sexual mores.

▣ ... Gustave Courbet's erotic painting Femme nue couchée, re-covered in 2005 after disappearing during World War II, had been given to a Slovak doctor in return for medical treatment.

■ ... Buried in the porch of St Alkmund's Church, Whitchurch is the heart of John Talbot, 1st Earl of Shrewsbury, who was killed at the Battle of Castillon in 1453.

■ ... The history of aspirin has been marked by fierce competition, patent and trademark battles, and even an international conspiracy known as the Great Phenol Plot.

■ ... Alexander Solzhenitsyn composed his 12,000-line-long poem Prussian Nights while imprisoned in a GULAG camp, each day writing down a few lines on a bar of soap.

■ ... Members of the Senegalese rap group Daara J were hired by campaigners in the Senegalese election of 2000 to edit their speeches.

■ ... Kiz, Utah, now a ghost town, was named for the first woman to settle in the area.

■ ... On the festival celebrated in the month of Toxcatl the Aztecs sacrificed, flayed and ritually cannibalized a young man who had been impersonating the god Tezcatlipoca for an entire year.

■ ... Neoclassical Italian sculptor Giuseppe Ceracchi portrayed George Washington with a Roman haircut and a toga.

■ ... Lady Florence Dixie feminist, big game hunter, war correspondent, and suffragette, was the aunt of Oscar Wilde's lover Lord Alfred Douglas.

■ ... Mole rats find their way home through their large burrows using the Earth's magnetic field.

■ ... Giovanni Faber, doctor to the Pope, botanist and art collector, coined the name "microscope".

■ ... Tibetan Buddhist monks attending a shedra university may be asked to completely memorize their school texts before they begin to study them.

■ ... Museum Wharf in Boston has a 40 ft tall milk bottle that was built during the Great Depression and transported to the wharf by barge in the 1970s.

■ ... Legend at Banagher says its church was founded by a saint, led there by a stag acting as a lectern and carrying a book on its antlers.

■ ... The author of the best-selling book Misha: A Mémoire of the Holocaust Years, who claimed to be a Holocaust survivor, admitted her memoir was a hoax.

■ ... The briefly popular "I'm Backing Britain" campaign in 1968 suffered embarrassment when a number of t-shirts bearing the slogan were found to be made in Portugal.

■ ... Hawkers in Kolkata, numbering 275,000, occupy pavements and generate annual business worth around 2 billion dollars.

■ ... A group of Philippine congressmen were named after the Spice Girls.

■ ... Seeds of the water lily Euryale Ferox may be toasted and eaten like popcorn.

■ ... The broadhead catfish, a carnivore, can be fed with rice bran.

■ ... Filipino poet José García Villa is known for his extensive use of commas, which made him known as the "Comma Poet".

■ ... Pig fat, cannabis oil, fish, scorpions and hot sand were used in various offensive weapons in ancient and medieval warfare.

▓ ... A poem by William Newton led to an end to gibbeting (publicly displaying) corpses in Derbyshire.

▓ ... The young leaves and flowering stems of Senecio Congestus can be made into a "sauerkraut".

▓ ... J.R.R. Tolkien was so incensed by the adaptation of proper names in the Dutch translation of The Lord of the Rings that he wrote a guide to advise future translators.

■ ... Stieg Larsson's posthumously published Swedish crime novel The Girl with the Dragon Tattoo, was a best-seller, critically compared with War and Peace.

■ ... Squab is the meat from a young domestic pigeon.

■ ... Uprisings broke out in 1916 over the jailing of Phan Xich Long, who declared himself Emperor of Vietnam and tried to arm his rebels with magic potion that supposedly made them invisible.

▨ ... People from County Carlow in Ireland are nicknamed "scallion-eaters" because in the early 19th century, Carlow town supplied most of the onions in Leinster.

▨ ... Dada artist Marcel Duchamp's Bottle Rack was mistakenly thrown away as garbage.

▨ ... The initial Vietcong reaction to the 1963 South Vietnamese coup that killed Ngo Dinh Diem was that it must have been a trick.

■ ... David Owen Dodd was a 17-year-old boy hanged as a Confederate spy in the American Civil War.

■ ... Lithuanian supermarkets offered cheaper beer, chocolate and soap to those who voted in the 2003 Lithuanian European Union membership referendum.

■ ... Ben Chapman, the actor who portrayed the Gill-man in Creature from the Black Lagoon, was a veteran of the Korean War.

▨ ... A Regius Professor of Civil Law was elected to parliament, gaoled, exiled, re-elected, kidnapped, put in the Tower, tortured, hanged, drawn and quartered, then beatified.

▨ ... The trial of Satanta and Big Tree was the first time Native American war chiefs were tried for acts committed during a war party.

▨ ... Disappointment is one of two primary emotions involved in decision-making.

■ ... The Israeli documentary Paper Dolls follows the lives of five health care providers from the Philippines who perform as drag queens.

■ ... The ghost town of Ajax, Utah was centred on an 11,000 square foot (1,000 m²) department store lying entirely underground.

■ ... After suing to gain Marc Hall permission to take his boyfriend to a Catholic high school's prom, David Corbett was appointed Canadian Superior Justice.

... Six-year-old Antonietta Meo could soon become the youngest saint (not a martyr) canonized by the Roman Catholic Church.

... Tennis pro Martina Navratilova lived with Vaudeville actress Frances Dewey Wormser and her husband when she arrived in the United States in the 1970s.

... Paul Feyerabend's autobiography Killing Time contains descriptions of his careers as an officer in the Wehrmacht, an operatic tenor and a philosopher of science.

▨ ... The Cottonmouth jack (a game fish) is so named because of its pure white tongue and mouth.

▨ ... When 74-year-old Irish politician Pól Ó Foighil was told he was too old to be an election candidate, he challenged the younger man to twenty push-ups.

▨ ... In 1916, footballer Bob Benson volunteered to replace an absent Arsenal teammate just before a game, only to collapse and die during the match.

▣ ... F. Scott Fitzgerald was furious when he read his wife Zelda's first novel, Save Me the Waltz, because she had used material he was planning to use in Tender Is the Night.

▣ ... In 2006, Tsering Chungtak became the first Tibetan ever to participate in a major international beauty pageant.

▣ ... The Casuarina Tree short stories set in the 1920s Malaya by W. Somerset Maugham came out of travels he paid for by working as a British spy.

■ ... Polish poet and political activist Apollo Korzeniowski was the father of novelist Joseph Conrad.

■ ... Two years after masterminding the murders of backpackers David Wilson, Mark Slater and Jean-Michel Braquet, Sam Bith was made a general in the Cambodian Army.

■ ... Laurence C. Jones, the founder of the Piney Woods Country Life School near Jackson, Mississippi, once convinced a white mob not to lynch him by telling them about his educational mission.

▦ ... The Olive Python, Australia's second largest snake, can eat prey as large as a wallaby.

▦ ... "Quickfire", a form of arson employed in Scandinavian blood feuds, was punishable by death only if the perpetrator was caught in the act and killed at the scene of the crime.

▦ ... The Indonesian occupation of East Timor claimed over 100,000 lives and was characterized by torture, forced disappearance and starvation.

■ ... At a debate about evolution in 1860, Bishop Wilberforce allegedly asked Thomas Huxley if it was through his grandfather or his grandmother that he claimed his descent from a monkey.

■ ... Olympic gold medal-winning swimmer Gail Neall was initially so bad that her coach filmed her as an example to other swimmers of what not to do.

■ ... The "sweaty saddle" aroma associated with Shiraz from the New South Wales wine region of the Hunter Valley is actually a wine fault.

▩ ... In the Japanese theatrical art known as Taishu engeki, it is not uncommon for fans to spend tens or hundreds of thousands of yen on gifts for the performers.

▩ ... In 1940, the USS American Legion transported a Norwegian Princess to the safety of America, along with a vital Bofors 40 mm gun to be used as a mass production prototype.

▩ ... The scientific name of the vase-shaped forest fungus Gomphus Floccosus means "woolly plug".

■ ... Historian J. Bowyer Bell was tear gassed in Belfast, held hostage in Jordan, shot at in Lebanon, kidnapped in Yemen and deported from Kenya.

■ ... The murder of Solomon P. Sharp was the inspiration for a number of literary works, including Edgar Allan Poe's Scenes From 'Politian'.

■ ... Traditional Chinese phoenixes in carved reliefs of the Qianling Mausoleum are modelled on ostriches.

▩ ... The official cause of the Great Fire of 1811, which lasted for three days and burned down the whole Podil neighbourhood of Kiev, was children playing with fire.

▩ ... Edgar Allan Poe satirized the concept of a self-made man in his story The Business Man using a character that makes his fortune cutting the tails off cats.

▩ ... The kiss between Luke Snyder and Noah Mayer on As the World Turns is the first kiss between gay male characters on a daytime American soap opera.

■ ... Every year 70,000 to 80,000 migratory birds visit Raiganj Wildlife Sanctuary - an artificially created forest in West Bengal, India.

■ ... The small private rooms called cabinets gave rise to the political sense of cabinet, after English monarchs began to discuss matters of state in these settings.

■ ... According to his Memoir, 18th century painter Julius Caesar Ibbetson was named after the caesarean section that delivered him after his mother fell on the ice.

■ ... The rivalry between Leeds United and Manchester United football clubs has its roots in the 15th century English civil war, the Wars of the Roses.

■ ... Seattle pioneer David Denny married his own stepsister, made and lost a fortune worth US$3 million, and survived an axe-blow to his head at age 67.

■ ... The Mauch Chunk and Summit Hill Switchback Railroad - the second railroad built in the United States, was a major precursor to the roller coaster.

■ ... Michiko Maeda, the first Japanese actress to appear nude in a mainstream film, was banned from Japanese cinema for 42 years for disobeying a director.

■ ... The French wine region of Châteauneuf-du-Pape has a wine law banning the overhead flying, landing or taking off of flying saucers.

■ ... While Isko Moreno was running for vice mayor in Manila in 2007, posters were distributed of him wearing only a Speedo.

▨ ... William Hogarth's prints Beer Street and Gin Lane contrast the misery of gin drinkers with the happiness and good health of those who drink beer.

▨ ... Heimir was a Gothic hero who evolved into a traitor through centuries of storytelling.

▨ ... John Percival, while headmaster of Rugby School, gained the nickname "Percival of the knees" because he was concerned about "impurity" and insisted that boys secure their football shorts below the knee with elastic.

■ ... Vineyard owners in the Provence wine region of Cassis used to hire prostitutes from Marseilles to assist with picking grapes at harvest time.

■ ... Award-winning biographer Jenny Uglow described her dictionary of women's biographies as "a mad undertaking, born of a time when feminists wanted heroines and didn't have Google".

■ ... The environment of Florida supports the breeding of 34 species of non-native fish, a higher number than any other place on earth.

▓ ... American trauma surgeon Tom Shires operated on both Texas governor John Connally and gunman Lee Harvey Oswald after the assassination of John F. Kennedy.

▓ ... Ethnographer Eric Mjöberg smuggled indigenous human remains out of Western Australia's Kimberley region while leader of the first Swedish scientific expedition to the area. Sweden returned all 18 boxes of them 90 years later.

▓ ... Charlie Fonville broke a 14-year-old shot put world record by almost twelve inches at the 1948 Kansas Relays but was not allowed to stay with the other athletes because he was African-American.

■ ... Childless Emperor Lý Thái Tông built Hanoi's One Pillar Pagoda which resembles a lotus in a pond, after dreaming that the bodhisattva Avalokiteshvara handed him a baby son.

■ ... Outspoken British judge Melford Stevenson once described a case before him as a "pretty anaemic kind of rape" because the accused's ex-girlfriend was the victim.

■ ... Two-time Olympic diving gold medallist Bob Webster won his first collegiate diving title for a junior college with no pool, training off a board in his coach's back-yard sand pit.

▦ ... Leading Canadian human rights activist Kalmen Kaplansky died in 1997 on International Human Rights Day.

▦ ... Boletus Pulcherrimus, a large red and brown pored mushroom from California and New Mexico, stains dark blue when cut or bruised.

▦ ... The Silver Appleyard is one of the best egg layers amongst large breeds of duck.

■ ... Horand von Grafrath is credited with being the first German Shepherd Dog.

■ ... After switching sides multiple times during the American Civil War, Benjamin Anderson committed suicide, saying he "would prefer being dead than disgraced".

■ ... Although the first type of wind turbine, the panemone, is one of the least efficient designs it is also one of the most commonly reinvented and patented.

■ ... Model Anna Loginova founded a female bodyguard firm in Russia because male bodyguards are sometimes made to wait outside restaurants while the client is inside.

■ ... Although clansmen or clanswomen of a Scottish clan may wear a Scottish crest badge, the actual crest and motto within the badge are the sole property of their chief.

■ ... Vermont coppers were the currency used in Vermont before it became a U.S. state in 1791.

■ ... Famed Hoosier poet James Whitcomb Riley would regularly supply the children of the Lockerbie Square with candy on his walks.

■ ... The Redside Dace is the only species of minnow (a small type of fish) to routinely feed on flying insects by leaping from water.

■ ... The indigenous Nambikwara language of Brazil has a special implosive consonant used only by elderly people.

▣ ... The wetlands of the Hudson Plains are "notorious for their large populations of biting insects".

▣ ... Joseph Farington kept a diary almost daily from 13 July 1793 until 30 December 1821 that has provided historians with insight into the London art world as well as first-hand accounts of important political events of the day.

▣ ... When Jean-Paul Sartre's classic first novel Nausea appeared in 1938, it was reviewed by Albert Camus, still a journalist in Algeria working on his own later-classic first novel, The Stranger.

■ ... Due to the change from the Julian to the Gregorian calendar in 1582, English letter writers often used two dates on their letters, a practice known as dual dating.

■ ... A discontinued 1980s hockey helmet by sporting goods manufacturer Cooper Canada Ltd. is today used in making a particular puppet.

■ ... The strength of the Ukrainian People's Army fell from 300,000 to just 15,000 after five months of war with Soviet Russia.

■ … Samuel Johnson wrote a satirical verse on the 21st birthday of his protégé Sir John Lade that - aside from correctly predicting his future career - partly inspired A.E. Housman's A Shropshire Lad.

■ … Epidemiologist Brian MacMahon showed for the first time that women who give birth early in life may have a lower risk of breast cancer.

■ … The name of Whangaroa Harbour, an inlet on the northern coast of the Northland Region of North Island, New Zealand, comes from the Maori lament "Whaingaroa" or "What a long wait" of a woman whose warrior husband had left for a foray to the south.

■ ... Comanche War Chief Carne Muerte's name means "dead meat" in Spanish.

■ ... Group 13 was a notorious group of Jewish Nazi collaborators within the Warsaw Ghetto, known as the Jewish Gestapo.

■ ... The Matsés language of Peru has undergone some mixing with other indigenous languages because the Matsés people previously had the custom of capturing women from neighbouring tribes.

■ ... La Mojarra Stela 1, a 4-ton artifact of the Epi-Olmec culture, features a Mesoamerican ruler and appears to record his ritual bloodletting and a "dripping sacrifice".

■ ... Marlon Brando's disinherited Tahitian grandson Tuki Brando became famous as a model for Italian men's Vogue at 16 and the face of Versace in 2007.

■ ... Herring Scad (Alepes Vari) from the Red Sea has high levels of luminescent bacteria living symbiotically with the fish as part of the fish's gut flora.

■ ... The bronze L'Âme de la France lay facedown on the ground from 1948 to 1968 after it fell from its pedestal during a tropical cyclone.

■ ... Oregon judge William G. East ordered Robert F. Kennedy to explain why the U.S. government should not pay a private attorney his fees who was ordered to defend a criminal defendant.

■ ... Women were forbidden to drink wine in ancient Rome (which the ancient Romans sweetened with lead) under the penalty of death or divorce.

■ ... Paul's walk, the central aisle of Old St Paul's Cathedral, was a grapevine for London gossip and news during the 16th and 17th centuries.

■ ... The name Alexandra was considered unlucky by the Romanov family because so many Alexandras in the family, including Grand Duchess Alexandra Alexandrovna of Russia, died young.

■ ... Immunologist Robert A. Good documented the importance of the thymus gland and tonsils in the immune system and performed the first successful human bone marrow transplant.

■ ... The Independent Learning Centre started the Railway School Car Program in 1926, in which a teacher lived in a train car that travelled to students in isolated Northern Ontario communities.

■ ... Dutch mannerist painter Cornelis Ketel began to paint with his toes towards the end of a successful career as a portraitist in Elizabethan London and Amsterdam.

■ ... According to an Iroquois legend, a woman eating roasted acorns intimidated an evil spirit of the tribe known as The Flying Head so much, he never returned.

▓ ... Unsinkable Sam was a ship's cat of both the Kriegsmarine and Royal Navy during the Second World War who survived the sinking of all three ships on which he served.

▓ ... A group of computer hackers called Anonymous have vowed to take down the Church of Scientology in a movement called Project Chanology.

▓ ... Catherine Dolgorukov had a premonition that her morganatic husband, Tsar Alexander II, would be assassinated.

■ ... British MP Ronnie Campbell accidentally supported National Fetish Day, thinking the word "fetish" meant "worry".

■ ... Armenian oil magnate Nubar Gulbenkian once sued his father for $10 million after his company refused him $4.50 for a meal.

■ ... According to Herodotus, Rhodopis was a fellow-slave with the poet Aesop.

■ ... The supervisor of a kosher restaurant is required to be a Shomer Shabbat, a Jew who observes the Sabbath.

■ ... Race car journalist and former race car driver Dr. Dick Berggren decided to stop teaching college psychology after he was called into the college president's office because he parked his race car in the faculty parking lot.

■ ... Houhora Mountain was the first part of New Zealand that the early explorer Kupe saw, but he thought it was a whale, according to Maori legend.

■ ... The work of the Galician poet Juan Rodríguez de la Cámara presents arguments for the superiority of women to men.

■ ... The Comanche War Chief Santa Anna was the first Comanche or Kiowa Chief to visit Washington D.C. in 1847, and was so overwhelmed with what he saw, he immediately advised his people to seek peace.

■ ... Almaco jack (a game fish) have been known to remove parasites on their skin by rubbing up against scuba divers.

■ ... Nazi Germany planned to starve tens of millions of Jews, Poles and Soviet citizens in order to simultaneously eliminate "surplus population" and feed German citizens and their army.

■ ... The poisonous mushroom Russula Emetica, commonly known as "the sickener", is hoarded and eaten by the Red Squirrel.

■ ... The Belgian cartoonist Karl Meersman was at first disqualified from a drawing contest at age thirteen, because the jury did not believe his drawing had been created by a child.

▨ ... The Drug Years - a documentary chronicling illicit drug use in the United States - features never-before-seen film of Ken Kesey and the Merry Pranksters' acid-fuelled bus trip across America in 1964.

▨ ... The Latin "familia" must be translated as "household" rather than "family", since neither classical Greek nor Latin had a word corresponding to the modern-day family.

▨ ... In the process of carbonic maceration, which is used to produce Beaujolais wine, fermentation takes place inside the individual grape berry.

▨ ... The director of the 1981 Spanish film Deprisa, Deprisa (English: Hurry, Hurry!) was accused of paying his cast in hard drugs.

▨ ... After his father told him to "Get out and make a living and don't ask me for a dollar", James Rand Jr. founded American Kardex, which purchased his father's company five years later.

▨ ... Annual construction of the St. Moritz-Celerina Olympic Bobrun in Switzerland takes three weeks, fifteen ice workers, 5,000 m³ of snow, and 4,000 m³ of water.

■ ... Frank Loughran played for the Socceroos at the 1956 Summer Olympics in Melbourne, scoring a goal in the first game his adopted country of Australia ever played in Olympic soccer.

■ ... New York City-born mathematician Judith Roitman serves as the guiding teacher of the Kansas Zen Center.

■ ... The effects of head trauma on memory can be seen by the post-operative results of HM (also known as "H.M." and "Henry M.," born 1926 in Connecticut), a patient who has been unable to form any new long-term memories since a surgical procedure performed in the 1950s.

▨ ... Japanese make-up artist Shu Uemura gained critical acclaim for transforming actress Shirley MacLaine into a Japanese woman.

▨ ... Soviet literature declared Russian the "world language of internationalism", denouncing French as the "language of fancy courtiers" and English as the "jargon of traders".

▨ ... The ancient Olympic athlete Milo of Croton reportedly drank 10 litres of the Calabrian wine Cirò every day. The same wine is still being produced today.

■ ... In O'Donnabhain v. Commissioner, the United States Tax Court is presented for the first time with the issue of whether sex reassignment surgery is tax deductible.

■ ... Fake names and scenes were given to actors auditioning for roles in the episode titled "Confirmed Dead" of the fourth season of ABC's television series Lost to limit the leak of spoilers.

■ ... Omar Osama bin Laden, son of Osama bin Laden, proposed a 3000-mile horse race to replace the Dakar rally, cancelled the week before due to al-Qaeda threats.

▒ ... The Tingari cycle in Australian Aboriginal mythology embodies a vast network of Aboriginal Dreaming songlines that traverse the Western Desert region of Australia, and is frequently the subject of Aboriginal Art.

▒ ... A successful experimental system must be stable and reproducible enough for scientists to make sense of the system's behaviour, but unpredictable enough that it can produce useful results.

▒ ... In Slavic vampire folklore, vampires could take the form of butterflies.

■ ... Future Soviet psychiatrist Yuri Nuller was sent into the Gulag for supposedly being recruited by the French secret service at the age of three.

■ ... Because of the laws pertaining to birth aboard aircraft and ships, it is possible for a person born in a British ship, anchored at a United States port, with a Chinese father and a Turkish mother, to have quadruple nationality.

■ ... The Koitsenko were the honorary elite of the Kiowa dog soldiers, whose tribal lore says they called themselves that because they had dreams or visions of dogs.

▓ ... Dhakis, traditional Bengali drummers, kill more than 40,000 egrets, pheasants, and herons and open bill storks every year to decorate their instruments with feathers.

▓ ... The Aboriginal Community Court is an Australian court that aims to reduce the overrepresentation of aboriginal criminal offenders in the justice system.

▓ ... When San Francisco-based photographer William Rulofson fell to his death, he was heard to have exclaimed, "I am killed".

■ ... The Pea Island Life-Saving Station on the Outer Banks of North Carolina was the first station of the United States Life-Saving Service to be staffed entirely by an African American crew.

■ ... The former chief architect of Yerevan, Arthur Meschian, was also one of the founders of Armenian rock.

■ ... Violent, porno-chic fashion photography in French and Italian Vogue influenced the sexualized glamour of cosmetics in the 1970s.

▨ ... The scientific name of the common Australian garden fungus Aseroë Rubra means "red disgusting juice".

▨ ... After Comanche prophet Isa-tai promised a coalition of Native American warriors they would be invulnerable in battle and they lost, he blamed a Cheyenne killing a skunk for negating his magic.

▨ ... 2005's Hurricane Kenneth brought heavy rainfall to Oahu and Kauai in Hawaii, enough for its name to be considered for retirement.

■ ... Stubbins Ffirth (an American trainee doctor) drank vomit and smeared bodily fluids over himself in an attempt to prove that yellow fever was not contagious.

■ ... Inuit fur trader Stephen Angulalik sold umbrellas and parasols at his trading post in Northern Canada, which were covered in white cotton and used by hunters to sneak up on sleeping seals.

■ ... There is a belief that a dip in the waters of Papanasam Beach, one of the beaches in Kerala, washes away sins.

▦ ... The Matisse Museum in Le Cateau was created by Henri Matisse himself in 1952.

▦ ... It is expected to take 17 years to design and build the first of Australia's new submarines.

▦ ... Mohammad Shukri played for the Malaysian Under-15 cricket team at the age of 18, and for the Under-19 team at the age of 20.

■ ... On August 5 1893, Cub Stricker of the Washington Senators baseball team was arrested after intentionally throwing a baseball into the crowd, which broke the nose of a fan.

■ ... Adelaide Johnson, sculptor of a memorial to women's suffrage in the US Capitol, was married in 1896 by a female minister, with two of her busts as bridesmaids.

■ ... The Directa Decretal (385 AD) was a strongly-worded letter written by Pope Siricius emphatically reminding priests of the perpetual celibacy required of them.

... Two teenage brothers from Poland escaped in 1985 to Sweden under a truck. This event was presented in a 1989 movie 300 Miles to Heaven.

... Karachi's Lyari River is the major contributor to the annual discharge of 200 million gallons of sewage and Industrial waste into the Arabian Sea.

... Cliff Friend co-wrote The Merry-Go-Round Broke Down - the theme tune of the Looney Tunes cartoon series.

■ ... French aristocrats saw Jean-François Millet's oil painting The Gleaners as an alarming glorification of the working classes.

■ ... The Poitou Ass is a rare breed of donkey with a shaggy coat.

■ ... Anna Borkowska, the mother superior of a Polish convent of Dominican Sisters in World War II, was the first to smuggle in grenades for the Vilnius Jewish ghetto insurgents.

■ ... When Lepreum was attacked during the period of the Olympic truce, the Spartan attackers were given a fine equal to 200,000 times that of a skilled worker's daily wage rate.

■ ... The U.S. Supreme Court ruled in Jones v. United States that a person found not guilty by reason of insanity of a misdemeanour crime can still be committed indefinitely to a mental institution.

■ ... The novels of Jane Austen became popular with the public only after the publication of A Memoir of Jane Austen in 1869.

■ ... A wheelhouse in archaeology is a prehistoric structure from the Iron Age found in Scotland that was neither a wheel, nor perhaps a house.

■ ... Confraternities, a type of Nigerian university student organization started by Nobel Prize laureate Wole Soyinka, are now linked with organized crime.

■ ... The Phylax Society, the first German Shepherd Dog club, disbanded because members could not agree whether the dogs should be bred for work or appearance.

■ ... "Big" Alma Spreckels once successfully sued an ex-lover for "personal defloweration".

■ ... After being kept indoors at an Illinois zoo for about three decades, a citizens' campaign secured Ziggy the elephant a new home.

■ ... Due to an error, the Pagsanjan Falls stamp, one of a series supposedly showcasing places of interest in the Philippines, actually shows a waterfall in California.

■ ... The recently discovered smallest snake in the world, Lepto-typhlops Carlae, is thought to be near the evolutionary limit of how small any snake could be.

■ ... Cortinarius Semisanguineus, whose common name is "Surprise Webcap", is a mushroom that smells of radishes.

■ ... Six of the seven candidates in the 1999 Algerian presidential election withdrew less than 24 hours before the election.

■ ... The town of Kent, New York, dealt with an excess Canada goose population around Lake Carmel by rounding them up while they were molting and distributing the meat to the poor.

■ ... In addition to insects, the diet of the Common Brown Lemur includes soil and red clay.

■ ... Alternative rock musician Maynard James Keenan (lead singer of Tool) owns and operates his own winery, Caduceus Cellars, in rural Arizona.

■ ... The Expert at the Card Table - one of the most famous books on magic and card tricks - was written in 1902 by S. W. Erdnase, an author whose identity has been an enduring mystery for over 100 years.

■ ... William Hogarth's The Distrest Poet depicts a very poor family living in a squalid garret while the man of the family - who fancifully pursues a literary career without regarding his family's poverty - attempts to write a poem entitled "Upon Riches".

■ ... Jeffrey Miles, a chief justice in Australia, once heard a case in which a woman sought damages for losing the opportunity to work as a prostitute following a fall in a supermarket.

■ ... The traditional song "Happy Birthday to You" was first sung at the Little Loomhouse of Louisville, Kentucky.

■ ... Tori Amos got the melody for her song 1000 Oceans from a "dark angel" singing to her in a dream.

■ ... Mutations in the FLNB gene cause boomerang dysplasia, a lethal congenital disorder in which the long bones of the limb deform into the shape of a boomerang.

■ ... Muhamed, a German horse, seemed to extract cube roots and tap out the answer with his hooves.

■ ... During 13th and 14th century Europe, a town clock-keeper would often be employed and paid high sums of money to monitor and regulate the town clock.

■ ... The Winchester Bible - the largest surviving 12th century English Bible - incorporated the skins of 250 calves.

■ ... Franz Kafka started his Diaries 1914 with this entry: January 2. A lot of time well spent with Dr. Weiss.

■ ... The New York-based mock metal/glam metal band Satanicide replaced their bassist when they became aware that he "secretly liked Billy Joel".

■ ... Strawhead is a 1982 play by American writer Norman Mailer about Hollywood icon Marilyn Monroe that takes its title from Monroe's real life code-name.

■ ... Cushion plants, which grow extremely slowly, can live for up to 350 years.

■ ... The book Goodnight Bush - a parody of Goodnight Moon satirizing the presidency of George W. Bush - was written by two former employees of U.S. Secretary of Defence Donald Rumsfeld.

■ ... When 20,000 Mennonites immigrated to Mexico from Canada in 1922, they were given freedom from taxation for 100 years so long as they supplied cheese to northern Mexico.

■ ... Tang Dynasty general Li Siye once bared his upper body and battered fleeing soldiers with his staff to stop a general panic.

■ ... Five detached human feet have been discovered on British Columbian beaches since August 2007, with no confirmed explanation.

■ ... Frank McEncroe, a boilermaker from rural Victoria, invented the Chiko Roll (an Australian savoury snack designed to be able to be eaten with one hand whilst drinking a beer with the other).

■ ... Administering a strong solution of coffee through the rectum by means of a Murphy drip was alleged to have been a treatment for shock at the Battle of Midway.

■ ... Ride the Lobster is an 800-kilometer long unicycle race around Nova Scotia.

■ ... Liverpool actor and guitarist Ozzie Yue used to flick pieces of paper at Paul McCartney in art class when they attended the Liverpool Institute High School for Boys.

▦ ... Burkina Faso contains the most elephants in West Africa, with Deux Balés National Park containing 400.

▦ ... Ferrante Pallavicino was the anonymous author of Il Divortio celeste (1643) - a satire wherein Jesus Christ asks God for a divorce from his eternal bride, the Roman Catholic Church.

▦ ... A swimmer escaped a crocodile attack in Nkhata Bay, Malawi by biting the crocodile on the nose.

■ ... Twin brothers Robert and Ross Hume became known as the "Dead Heat Kids" after finishing nine straight mile races, including the Big Ten and NCAA championships, holding hands in dead heat victories.

■ ... California Governor Arnold Schwarzenegger, who played Conan the Barbarian in the 1982 film, proposed a law in 2007 for regulating the sales of violent video games such as Conan.

■ ... The scaly hedgehog is actually a species of brown mushroom found in spruce forests and used to dye wool in Norway.

▓ ... Average people use sub-personalities to allow them to cope with certain types of psychosocial situations.

▓ ... Bette Midler's back-up trio The Harlettes once included the actress Katey Sagal, better known for her role as Peggy Bundy on the television series Married...with Children.

▓ ... The Mormon practice of polygamy was first inspired in 1831 when Joseph Smith said Jesus wished his followers to marry Native Americans to make their descendants white.

■ ... Several years after Henry Wadsworth Longfellow published The Village Blacksmith, a chestnut tree mentioned in the poem was made into a chair for the poet.

■ ... Shukr is the Islamic virtue of gratitude.

■ ... Dr. Maressa Orzack at Harvard Medical School stated that 40 percent of World of Warcraft players were addicted.

▨ ... John Boylan, who won an acting award for his role in the play On the Harmful Effects of Tobacco, eventually died of lung cancer.

▨ ... The Flying Super Saturator was the world's first roller coaster allowing riders to dump water on other amusement park attendees.

▨ ... Kermit the Frog was named after Kermit Scott, a childhood friend of Muppets creator Jim Henson.

■ ... Before the 17th century, penetrating trauma was treated by pouring hot oil into wounds to cauterize damaged blood vessels.

■ ... Australian fishermen often refer to the Western school whiting as "bastard whiting" because its presence in the catch reduces the presence of targeted species.

■ ... André Devigny, a member of the French Resistance, escaped the allegedly escape-proof Fort Montluc Gestapo prison using a safety pin, a spoon, a rope, and a grappling hook.

▦ ... An exploding cigar was at the heart of an alleged plot by the Central Intelligence Agency to assassinate Fidel Castro.

▦ ... In 1582 Ursula Kemp confessed to using familiar spirits to kill her neighbours and was later hanged for witchcraft.

▦ ... Quirinus Kuhlmann, a German poet who called himself "son of the Son of God", was denounced as theologically and politically dangerous and was burnt at the stake for heresy in Moscow in 1689.

■ ... Some species of Vireo, a genus of passerines, bind their nests with spider silk and ornament them with spider eggs.

■ ... Hugh Daily, a pitcher with only one arm, once struck out 19 batters in a Major League Baseball game.

■ ... Fred Walker helped to boost sales of his new spread Vegemite, now an Australian cultural icon, by giving free jars to customers.

■ ... Agnolo Bronzino's 1542 painting of Bia de' Medici (the illegitimate daughter of Cosimo I de' Medici, Grand Duke of Tuscany) was painted from the girl's death mask.

■ ... Alojzy Ehrlich ate rolls and a Polish sausage while playing a table tennis match in which neither he nor his opponent scored for over an hour.

■ ... The chief purpose of the military order The Militia of Jesus Christ was to combat heresy.

■ ... The Brazilian team at the 1958 World Cup had not assigned squad numbers in advance, and a 17-year old Pelé was randomly assigned the number 10, which he wore for the rest of his career.

■ ... Local legends say that a white witch lives in Mother Ludlam's Cave near Waverley Abbey in Surrey, South East England.

■ ... Irish computer programmer Gavin Walsh owns the world's largest collection of Sex Pistols records and memorabilia.

... Australian veterinary student Barry Larkin carried a fake Olympic Flame in the 1956 Summer Olympics as a protest, because he thought the flame was given too much reverence.

... Robert Redford made one of his last guest-starring appearances in a television series in a 1963 episode of the ABC psychiatric drama Breaking Point.

... The Biographicon aspires to be an online directory of biographies for "all the people of the world".

■ ... Lloyd Baron Rhododendron Garden in Rood Bridge Park includes some 550 varieties of rhododendron, the official flower of the city of Hillsboro, Oregon, USA.

■ ... Princess Margaret of Prussia had her jewels stolen by American soldiers in the aftermath of World War II.

■ ... Jewish American surfer Doc Paskowitz helped bring surfboards to Gaza to promote peace in the Israeli-Palestinian conflict.

■ ... Despite writing a full action-and-dialogue screenplay for his film Raising Victor Vargas, Peter Sollett never showed the actors a script to encourage authenticity through improvisation when filming.

■ ... Tropical botanist Paul H. Allen assembled one of the most important collections of banana germplasm.

■ ... Real-life medical cases in the book The Medical Detectives, by Berton Roueché, inspired many of the medical mysteries on the television show House.

■ ... Despite its bitter taste, the heart of the palm tree Plectocomiopsis Geminiflora is a delicacy in Borneo.

■ ... Despite its name, the Badminton Library of Sports and Pastimes does not contain a single volume about badminton.

■ ... Antley-Bixler syndrome is a rare but severe congenital malformation disorder with symptoms that include flat forehead, closure of cranial sutures and fused bones in the limbs.

... Audrey Stubbart worked until age 105, becoming the oldest verified full-time employee ever in the United States.

... Residents of 22½ St. in Minneapolis petitioned the City Council and changed the street's name to Milwaukee Avenue because the '½' made them feel as if they lived in an alley.

... Charles J. O'Byrne, Secretary to Governor David Paterson of New York, is a former priest who officiated at the marriage of John F. Kennedy Jr. and Carolyn Bessette in 1996 and presided over their funeral in 1999.

■ ... During a Fersommling (a Pennsylvania Dutch social event), the only language spoken is Pennsylvania Dutch and anyone who speaks English has to pay a fine for each word.

■ ... In 1847 French Admiral Jean-Baptiste Cécille sent a captain to attack Vietnam to obtain the release of a bishop, not knowing the bishop had already been freed.

■ ... A riot reportedly instigated by writer André Breton broke out during the 1923 premiere of Tristan Tzara's Le Coeur à gaz - a play written as a nonsensical dialog between human body parts.

■ ... The 1927 disappearance of the French biplane The White Bird (L'Oiseau Blanc) in an attempt to make the first non-stop transatlantic flight from Paris to New York, is one of the great unexplained mysteries of aviation.

■ ... Sugar cream pie is being considered to become the official state pie of Indiana, USA.

■ ... According to Brunei folklore, Nakhoda Manis disrespected his mother, which caused a storm to sink his ship in the Brunei River, transforming the ship into the rock known as Jong Batu.

■ ... Dr. Seuss's book The Seven Lady Godivas is one of his only books written for adults. Though it was initially a failure when first published in 1939, original editions have sold for upwards of US$300.

■ ... Ablative brain surgery - which involves destroying brain tissue by heat or freezing - was used until recently in the People's Republic of China to treat people with schizophrenia.

■ ... Swedish soldier Charles F. Henningsen participated in civil wars and independence movements in Spain, Nicaragua, Hungary and the United States, but died without ever winning any of the causes for which he fought.

▓ ... The lawsuit of Motte v. Faulkner in 1735 was a legal dispute over the right to publish Jonathan Swift's complete works and its outcome was viewed by Swift as another example of English oppression.

▓ ... The Mark Eden Bust Developer, a product claimed to enlarge women's breasts, actually worked by increasing the pectoral and back muscles.

▓ ... The 12th century Kannada poet Harihara was initially an accountant in the Hoysala court.

■ ... Turkey was so dissatisfied with its first set of stamps that it had France make the second set.

■ ... Samuel Johnson failed to get a job at Brewood Grammar School because headmaster William Budworth was concerned with Johnson's head movements.

■ ... A shrew's fiddle was used to punish women who were caught fighting or arguing in Germany and Switzerland, and slaves in the United States.

▓ ... U-boat commander Heinrich Bleichrodt refused to wear his Knight's Cross until his subordinate, Reinhard Suhren received one as well.

▓ ... NASCAR took away the first win from its all-time most winning driver at Lakewood Speedway after his father protested the scoring.

▓ ... The annual Chembuduppu festival at St. George Orthodox Church, Chandanapally is held in commemoration of non-Christians who brought rice to feed hundreds of voluntary labourers during its construction.

■ ... The herb Forsskaolea Tenacissima was so named by Carl Linnaeus because it was as stubborn and persistent as his student Peter Forsskål had been.

■ ... Captain Woodes Rogers rescued Alexander Selkirk, the model for Robinson Crusoe, and later defeated the pirates of the Caribbean.

■ ... In 1912, a Singer motorcycle became the first 350cc motorcycle to cover more than 60 miles (97 km) in one hour.

■ ... The first East Lake Community Library in Minneapolis was called a "reading factory" because it looked like a storefront.

■ ... Male prostitutes in Pakistan generally range from fifteen to twenty-five years of age.

■ ... The Berthouville Treasure of first and second-century Roman silver was uncovered accidentally by a farmer's plough in 1830.

■ ... Cheryl Dunye's 1996 film The Watermelon Woman was the first feature film to be directed by a black lesbian.

■ ... Maher Arar was deported to Syria and tortured after being wrongly identified as an "Islamic extremist" by Project O Canada.

■ ... Perth is the first city to operate a reverse osmosis seawater desalination plant to provide drinking water in Australia.

■ ... A scandal arose when African-American actor Lorenzo Tucker (known as the "Black Valentino") playing a pimp in a play, kissed Mae West, playing a prostitute.

■ ... Pierre the penguin is the first bird to don a custom-made wetsuit (to combat bald-spots).

■ ... The seeds of Trillium Grandiflorum are dispersed by ants, which interpret the seeds as corpses.

■ ... The government of Malaysia has been alleged to be behind Project IC which involves the systematic granting of citizenship to hundreds of thousands of immigrants in order to alter the demographic and voting pattern in their favour.

■ ... Merkhets were Ancient Egyptian timekeeping devices that tracked the movement of certain stars over the meridian in order to ascertain the time during the night, when sundials could not function.

■ ... Young shoots of the ornamental Australian tree Alphitonia Excelsa give off an odour of sarsaparilla when broken.

■ ... The first wife of Arizona Territorial Governor A.P.K. Safford printed notices accusing him of having a venereal disease.

■ ... Florentine law required the commissioning of unflattering frescoes or pittura infamante (defaming portrait), on the exterior of the Bargello of those found in contempt of court for financial offences.

■ ... Gallery owner Victoria Miro described Jake Chapman—now famous for art which includes explicit and distorted mannequins—as an "adorable" baby sitter.

■ ... Julian Sturgis, the novelist, poet, librettist and lyricist was the first American to win an English FA Cup Final in 1873.

■ ... McDonald's signs once had only one golden arch.

■ ... Igor Stravinsky agreed to compose the musical score for the ballet Circus Polka only under the condition that the elephants performing it be very young.

▦ ... Kettle Falls, known to native peoples as Shonitkwu ("roaring or noisy waters"), lies silenced beneath the waters of Lake Roosevelt, trapped behind the Grand Coulee Dam.

▦ ... The Unlearned Parliament was so called because lawyers were forbidden to attend as Henry IV felt they were "troublesome".

▦ ... The sales of the "miracle drug" Energon, consisting of calf brain, sugar and milk, were able to establish Pharmacia as a major pharmaceutical company in Sweden in the early 1900s.

■ ... The first printing press in Sierra Leone was destroyed by the French before it could be used.

■ ... Allumette Island (Quebec, Canada), the largest island in the Ottawa River, was once called One-Eyed Island because Algonquin chief Tessouat had only one eye.

■ ... Susanna Clarke's novel Jonathan Strange & Mr Norrell has 185 footnotes, which contain a meticulous false history of English magic and an entire fictional corpus of magical scholarship.

■ ... Certain flies such as the Cayman crab fly Drosophila Endobranchia live solely in and on land crabs.

■ ... Edgar Allan Poe's 1831 short story Bon-Bon features an amateur philosopher who meets a soul-eating devil.

■ ... The cultures of the Western Mexico shaft tomb tradition not only considered dogs to be soul guides for the dead, but a major source of protein as well.

■ ... In 1877 the 4,000-seat Queen's Theatre staged a spectacular and expensive production of The Last Days of Pompeii that flopped: the earth did not quake, the volcano did not erupt, and acrobats fell onto the cast.

■ ... Antiquarian Antonio Francesco Gori is alleged to have stolen Galileo's finger when the scientist's remains were transferred in 1737 to Santa Croce, Florence.

■ ... Gibraltar passports are full British passports that are particularly issued to Gibraltarians and only differ in some wording.

▨ ... Mavia was an Arab queen who in 378 AD, personally led her troops out of southern Syria in revolt against Roman rule.

▨ ... The 1979 Dechmont Woods Encounter in West Lothian, Scotland, is the only UFO sighting in the United Kingdom to have become the subject of a criminal investigation.

▨ ... George "Crybaby" Cannon got his nickname from being able to wipe sweat from his face to make it appear as though he was crying.

■ ... According to Muisca mythology, Bochica saved his people from a flood by creating the Tequendama Falls with a strike from his staff.

■ ... Legendary Polish boxing champion Antoni Czortek fought for his life in boxing matches while at Auschwitz.

■ ... Stalag fiction was a genre of Israeli pornography about concentration camp imprisonment, brutalization by female SS guards, and the prisoners' revenge.

▨ ... A tropical greenhouse and sturgeon farm in the Swiss Alps, powered by geothermal energy from the world's longest land tunnel, is intended to produce two tonnes of caviar annually.

▨ ... Although Desmond Lardner-Burke, Minister of Justice in Rhodesia, died in the 1980s, his name appeared on the electoral roll for the Zimbabwean parliamentary election, 2008.

▨ ... After making the first ascent of the remote Mount Lucania, Robert Bates was forced to survive on squirrels and mushrooms during his 156-mile (251 km) trek out of the wilderness.

■ ... Scientists are unsure why Lake Phalen in Saint Paul, Minnesota, is home to a population of rainbow darters - a fish normally found in fast moving streams.

■ ... By the time the Florida Supreme Court finally ruled that William D. Bloxham had won the 1870 Lieutenant Governor election, it was 1872 and the term was effectively over.

■ ... 50 years after winning A£100 in a fridge decorating competition, Australian artist Robert Dickerson commands from A$80,000 for a painting today.

▓ ... Miller's Court in Dorset Street was the location of the last murder by Jack the Ripper on November 9, 1888.

▓ ... The Fiji Woodswallow is highly aggressive to predators and will harass the much larger Fiji Goshawk and Peregrine Falcon.

▓ ... During the Third American Karakoram Expedition's attempt to climb K2, Pete Schoening saved the lives of six falling climbers.

■ ... Myrialepis Paradoxa, a species of palm trees native to Southeast Asia, is used to make thatched baskets.

■ ... On a per capita basis, foreign aid donated by Saudi Arabia is one of the highest in the world.

■ ... Scottish actor Russell Hunter was so concerned about being identified with "Lonely", the anxious, smelly sidekick he played in the 1960s spy series Callan, that he took pains to smell nice.

▧ ... Troco, also called "trucks" or "lawn billiards", is a traditional English lawn game played with wooden balls and long-handled cues at the ends of which are spoon-like ovals of iron.

▧ ... Of the twenty-five clipper ships owned by the Loch Line, which operated between the United Kingdom and Australia, seventeen were lost at sea.

▧ ... The ancient Egyptians set up hundreds of ka statues in Abydos so the dead could participate in religious festivals.

■ ... During a Viking funeral, human sacrifice was performed with sexual rites.

■ ... Groucho Marx joined Hillcrest Country Club even though it was willing to have him as a member.

■ ... Every receipt issued by Taiwanese businesses, known as the Uniform Invoice, is also a lottery ticket.

▨ ... More than a dozen artists have recorded live albums in the back room of McCabe's Guitar Shop, including Tom Waits, Beck and R.E.M.

▨ ... The Michigan Wolverines' practice of parading their live mascot Biff before matches was stopped as the animal grew larger and more ferocious.

▨ ... Stone Bridge in Saint Petersburg, Russia was so steep that in the 19th century, bus passengers had to disembark in order for the bus to go over it.

■ ... The globe in the initial release of the NT$1,000 fifth series of the New Taiwan Dollar banknote was mirror-reversed.

■ ... Turkey bowling, protested by animal rights activists, was invented as a pastime in the aisles of a grocery store.

■ ... Wiener sausages are named after the mathematician Norbert Wiener.

▨ ... The winner of the Ernie Awards (an Australian award for sexist comments) is the person who gets the loudest boos from the audience.

▨ ... The World Snail Racing Championships were held annually for over 40 years, with only the 2007 event cancelled due to inclement weather.

▨ ... Six latrines at Black Moshannon State Park in Pennsylvania are listed on the National Register of Historic Places.

■ ... Men can be insured against alien impregnation.

■ ... In a few villages and towns of southern France and Spain it is illegal to die. Attempts have been made to have the same law in a town in Brazil.

■ ... American entrepreneur Timothy Dexter defied the popular idiom and actually made a profit when he sold coal to Newcastle.

■ ... Numerous wells and springs were dedicated to Saint Quirinus of Neuss, who was invoked against the bubonic plague, smallpox, gout, and a siege of the city of Neuss during the Burgundian Wars.

■ ... The practices of the Followers of Christ church in Oregon, United States, - which include faith healing and forbid medical treatment - prompted a 1999 state law making parents liable if their children are harmed by a lack of treatment.

■ ... Georgia Tech professor Rebecca Grinter supervised a 2005 study that found iTunes users in the workplace experience "playlist anxiety".

■ ... Captain Michael Heck was an American B-52 pilot in the Vietnam War who became a conscientious objector and refused to continue bombing North Vietnamese targets during the Christmas operation of 1972.

■ ... The presence of certain insects in a corpse may be indicators of elder or child abuse.

■ ...Jazz drummer Butch Ballard was hired by Duke Ellington as a backup drummer due to the excessive drinking of his regular drummer Sonny Greer.

▨ ... Hindus believe that the god Vishnu falls asleep in the cosmic ocean of milk on the cosmic serpent, for a period of four months on the day of Shayani Ekadashi.

▨ ... Gloria Shayne Baker and Noel Regney co-wrote the Do You Hear What I Hear? Christmas carol as a plea for peace during the Cuban Missile Crisis.

▨ ... Reginald Turvey, "The Father of the Bahá'ís of South Africa", spent 13 years unaware that there were fellow believers in the Bahá'í Faith in his country.

■ ... It took Midvinterblot (a controversial painting from Sweden) 82 years and a detour to a Japanese collector before it could finally be installed where it was intended to be.

■ ... The ITV Network Centre did not want to broadcast the first series of Cold Feet at 9 p.m. because that was a timeslot traditionally reserved for programmes that viewers could do their ironing to.

■ ... Lord Francis Douglas fell 4,000 feet (1,200 m) to his death shortly after sharing in the first ascent of the Matterhorn.

■ ... The Forum Against Islamophobia and Racism is a Muslim advocacy group that monitors media coverage of Islam and Muslims in the U.K.

■ ... According to Inca mythology, lunar eclipses are caused by animals attacking Mama Quilla, the goddess of the moon.

■ ... Production of the cervelat (the Swiss national sausage) is set to cease in 2008, causing a public upset in Switzerland.

■ ... Polish Countess Delfina Potocka served as muse to both Romantic poet Count Zygmunt Krasinski and composer Frédéric Chopin— both of whom wrote works in her honour.

■ ... Katie Sierra was accused of treason and suspended from high school in October 2001 for attempting to start an anarchist club.

■ ... Captain Philip Beaver once read the entire Encyclopaedia Britannica during one of his cruises.

■ ... Carl Størmer, "the acknowledged authority" on aurorae and the motion of charged particles in the magnetosphere, began his academic career inventing formulae for π.

■ ... Quite Interesting Limited provides the research for UK TV programme QI and The Museum of Curiosity.

■ ... After the 1862 trial of poisoner Catherine Wilson, the judge, John Barnard Byles, described her as "the greatest criminal that ever lived".

■ ... The Roman Emperor Maximian was forced to abdicate on three separate occasions.

■ ... Drag racer Al Hofmann had to get a friend to come over to start his first Funny Car.

■ ... The earliest full-length portrait of Elizabeth I by Tudor court painter Steven van der Meulen, was auctioned by Sotheby's in 2007 for £2.6 million - more than twice its expected maximum.

▨ ... The goddess Hathor was worshipped by miners in ancient Egypt.

▨ ... The Lackham campus of Wiltshire College created a "virtual farm" in 2005 to avoid limitations to practical teaching caused by foot and mouth disease.

▨ ... Video sharing website YouTube has held two YouTube Awards, which honour the best videos on the site, as voted by the YouTube community.

■ ... The petioles (the small stalk attaching the leaf blade to the stem) of some species of Eugeissona palm trees can be used as darts in blowgun hunting.

■ ... Home of Truth, Utah was a religious utopian community in the 1930s whose leader claimed to receive divine revelations through her typewriter.

■ ... Siam Park, a water park under construction in Adeje, Tenerife, will have the world's largest collection of Thai buildings outside of Thailand.

▓ ... In addition to the 22 suspects listed by the Los Angeles District Attorney in the notorious unsolved Black Dahlia case of 1947, about 60 people confessed to the crime.

▓ ... The tropical fish Cleftbelly Trevally (A. atropos) has no scales on its chest between its pectoral and pelvic fins.

▓ ... The first major international chess tournament took place in London in 1851.

■ ... Helen Abbott Michael - originally trained as a pianist - became a plant chemist and earned her MD after a chance purchase of Helmholtz's Treatise on Physiological Optics on a trip to Europe.

■ ... A trio of pet Mexican Spinytailed Iguanas released on Gasparilla Island, Florida by a resident in the 1970s has led to a current population explosion of over 12,000 lizards.

■ ... The Westinghouse Time Capsules of the 1939 New York World's Fair and the 1964 New York World's Fair were made of special metal alloys to resist corrosion for 5000 years - the time span of all previous recorded human history.

■ ... The Caltech (California Institute of Technology) hacker who used a remote control to alter the scoreboard at the 1984 Rose Bowl received college credit for the prank.

■ ... The 1929 film The Surprise of a Knight is the earliest known gay, hardcore pornographic film in American cinematic history.

■ ... According to the martyrology, the early 4th century Christian martyr Aedesius of Alexandria was tortured and drowned for striking a judge who had been forcing consecrated virgins to work in brothels.

■ ... Although Horse-eye Jack (Carnax Latus) generally fear scuba divers, schools of them have been known to swarm divers because they are attracted to the bubbles a person exhales.

■ ... Many streets in Coconut Grove, Northern Territory, Australia are named after victims of the shipwreck of SS Gothenburg off the coast of Queensland in 1875.

■ ... Nigerian John Ezzidio - who was freed from a slave ship and landed in Freetown, Sierra Leone in 1827 - became the city's mayor eighteen years later, in 1845.

■ ... The Black Spiny-tailed Iguana of Central America is the world's fastest lizard, being clocked at 21.7 miles per hour.

■ ... Yve Lavigueur, who initially became famous as a member of a family that won the biggest lottery jackpot in Canadian history in 1986, later published a book in 2000 on how they lost it all.

■ ... German-American inventor Philip Diehl invented the ceiling fan in 1887 using a sewing machine motor.

■ ... Grand Duke Sergei Mikhailovich of Russia shared his mistress with one of his cousins for almost two decades.

■ ... Tabasco sauce heir Edward Avery McIlhenny was an arctic explorer who in 1897-98 helped to rescue over a hundred whaling fleet sailors stranded at Point Barrow, Alaska.

■ ... Scientist and concert pianist Manfred Clynes used principles of neuroscience to develop SuperConductor - a computer program that can "perform" classical music with its own expressive intonation.

■ ... French adventurer Marie-Charles David de Mayréna was supposed to negotiate treaties with the local people in an 1888 expedition to present-day Vietnam, but instead formed a new Kingdom of Sedang with himself as the king.

■ ... Gay screenwriter Marco Pennette was outed in front of his parents on the People's Choice Awards red carpet by a colleague who asked him about his boyfriend.

■ ... The Hindu serpent goddess Manasa, the "destroyer of poison", is worshiped mostly in the rainy season when the snakes are most active.

■ ... Campanula Gelida, an endemic species of a bellflower, grows in nature only on one rock in the Czech Republic.

■ ... The Faun, a rare sculpture by Paul Gauguin, displayed for a decade by the Art Institute of Chicago and the van Gogh Museum in Amsterdam, was actually a fake by British forger Shaun Greenhalgh.

■ ... The Ramesseum medical papyri (a collection of ancient Egyptian medical documents) contained a contraceptive formula and a method to predict the likelihood of a newborn's survival.

■ ... Consuming excess carotenoids (found in carrots) may lead to their deposition in the stratum corneum and a yellow to yellow-orange discoloration of the skin in a medical condition known as carotenoderma.

■ ... The Skyscraper Index has shown that the world's tallest buildings have risen on the eve of economic downturns.

■ ... American artist Sybil Gibson started painting in 1963 aged 55, using the medium of powdered tempera paints on brown paper grocery bags.

■ ... The Tigmamanukan, a Philippine mythological bird, can be a good or bad omen depending on the direction of its flight.

■ ... Gustave Ferbert quit his job as head football coach at the University of Michigan in 1900 to prospect for gold in the Klondike Gold Rush and returned home in 1909 as a millionaire.

■ ... Besides utility poles, anonymous knitters from Knitta have also left their tags on the Great Wall of China and the Notre Dame de Paris.

▨ ... Paramilitary loyalist Tommy Herron declared war on the British Army, but called it off after two days.

▨ ... The village of Kodinji in Kerala, India, where multiple birth is a regular phenomenon, is home to over 204 pairs of twins.

▨ ... The 17th chief of the Clan Maclachlan was killed by a cannonball while leading his Jacobite clansmen at the Battle of Culloden in 1746.

■ ... Many churchgoers in the 1920s believed that Ronald Reagan's mother, Nelle Wilson Reagan, had the gift to heal due to her strong belief in the power of prayer.

■ ... Irish playwright George Farquhar originally planned on an acting career but gave it up after accidentally wounding a fellow actor severely on stage with a sword.

■ ... In the 17th century, south-London prostitutes (nicknamed Winchester Geese after the Bishop whose land they worked on) were buried in a special, unconsecrated graveyard called Cross Bones.

▨ ... People with patent foramen ovale - an atrial septal defect - are more likely to suffer from migraine headaches.

▨ ... After turning up drunk at an official dinner, crowing cock-a-doodle-doos, and throwing himself on an ambassadress, J.B. Manson retired as Director of the Tate gallery and returned to painting flowers.

▨ ... Powderfinger's D.A.F. was named after its chord progression, rather than its subject matter like most popular songs.

■ ... The 18th century publisher Ralph Griffiths erected a sign outside his shop warning dunces that his Monthly Review would have no mercy in exposing and shaming dull authors.

■ ... The skin of the Austrian white wine grape Zierfandler turns red just before it is ready to harvest.

■ ... According to the Christmas Price Index it will cost your true love US$78,100 to buy you all those gifts (from the Twelve Days of Christmas song) this year.

▓ ... IBM's Automatic Language Translator machines used by the US Air Force had optical disks that stored thousands of Russian-to-English translations.

▓ ... The Tierpark Hagenbeck zoo of Hamburg, Germany was the first to use moats instead of cages to separate the animals from the public.

▓ ... Stanley Green, the "Protein Man", walked up and down Oxford Street in London every day for 25 years (sometimes in green overalls to protect himself from spit) warning passers-by about the dangers of too much protein —and sitting.

■ ... Stitch markers are mnemonic devices that demonstrate the underlying mathematical basis of crochet.

■ ... Cornelius Shea, the founding president of the Teamsters, spent more than five years in Sing Sing prison for slashing and stabbing his mistress 27 times.

■ ... The pun riddle "What do you call a spicy missile? A hot shot!" was generated by a computer as part of computational humour research.

■ ... The man intensely reading in the oil portrait The Bookworm represents the inward looking attitudes that affected Europe during the time of its creation.

■ ... Enriqueta Favez, a Swiss woman, studied medicine and served as an army surgeon in the Napoleonic Wars disguised as a man. Favez later went to Cuba in the 1820s and married a local woman.

■ ... The Invasion of Minorca in 1781 by Spanish and French forces succeeded after more than five months, because the British defenders had no fresh vegetables.

■ ... Drunken trees result from permafrost thawing.

■ ... Rudyard Kipling wrote a short story about a group of World War I soldiers who were committed Janeites, that is, fans of Jane Austen novels.

■ ... "Bunchers" are criminals involved in kidnapping pets from residences, trapping stray animals illegally, and selling them to laboratories for animal testing purposes.

■ ... As a result of his role in the Peasants' War, the German Renaissance painter Jerg Ratgeb was executed by being torn apart by four horses.

■ ... Skuon town in Cambodia's Cheung Prey District is famous for fried spiders seasoned with garlic and salt.

■ ... Lucien Galtier, the first Roman Catholic priest in Minnesota, was responsible for renaming the city of Saint Paul, Minnesota, from its previous name of Pig's Eye.